You have to do stuff that average people don't understand, because those are the only good things.

-Andy Warhol

D1640624

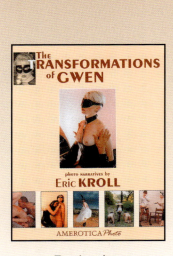
We have over 150 titles,
write for our color catalog:
NBM
555 8th ave., Ste. 1202
New York, NY 10018
See our website at
www.nbmpublishing.com

See Eric Kroll's site at
www.fetish-usa.com

©2001 Eric Kroll
Drawing "The Hornet" ©E.Meyerstein
ISBN 1-56163-304-6
Printed in Hong Kong

5 4 3 2 1

Amerotica Photo is an
imprint and trademark of

NANTIER ◦ BEALL ◦ MINOUSTCHINE

Publishing inc.
new york

The TRANSFORMATIONS of GWEN Vol.2

photo NARRATIVES by Eric KROLL

AMEROTICA Photo

FOREWORD
Round 2

An email from a Gwen admirer:
"Isn't it strange how photographs can conceal/reveal the true nature of a human?

Even with the multitude of pictures Gwen appears in, her true form remains a mystery. Two photos placed next to each other reveal completely different women- expressions, coloring, even facial structure, yet something eludingly tangible prevails. Perhaps this is one of your talents, freezing time and using light to resculpt the familiar."

I have my black and white film processed south of Market

Street in downtown San Francisco. Recently, I went in to pick up some shots I had done of Gwen at a 1950's style motel in Paradise, California. The concept was: young woman, unable to get to a bathroom, ends up peeing in her pants. It has always been a fantasy of mine. Gwen helped me to flesh it out. The bespectacled man behind the counter, withholding my envelope of contact sheet and negatives, said in a stern tone of voice: "I guess it has come to that point Mr. Kroll where I have to ask you if all the models you photograph are of age?"

In the town where photographer Jock Sturges was bothered by the authorities, I was alarmed. Indignant. Regaining my composure, I explained these were photographs of the same woman I have always photographed. "She is 26 years old and living with ME." She was wearing a wig but it was classic Gwen. Once again she had transformed.

———◆◆◆———

In Skin Two magazine's review of The Transformations of Gwen vol. 1, Tony Mitchell made an important distinction about my photographs of Gwen. "While the action might have been staged for the camera, it has not been faked for the camera by people not really 'into it'." Correct. Gwen is my muse. Gwen is the person I photograph incessantly. It helps that Gwen, on her own volition, is into SEX. Like the fetish master John Willie, I have no interest in the nude woman. She must be accessorized in fetish. High heels, black seamed stockings or perhaps a spandex vintage open-bottom girdle. These many things propel my imagination. I found in a small antique store in Mill Valley, California a lithograph from the 1930's, of a woman dressed in a wasp costume. Fabulous. Joyful. Extreme. And an inspiration. Today Gwen and I visited our new seamstress in the Mill Valley hills. I brought her 2 pair of high-waist white cotton panties with re-enforced leg cuffs. I asked her to cut the crotch of one and amend it with 3 small white pearl buttons so that the lover of

the woman wearing the panties could release the crotch and fuck her while she continued to wear the panties. I asked my seamstress to cut two holes in the crotch of the other pair of cotton panties and reinforce the holes with heavy thread so that a man's penis could fit through one or both of the holes. Some men are obsessed with panties.

PLEASURE CLEVERLY DISGUISED AS BUSINESS

I'm fifty-four years old. I've been taking 'girlie' photographs since 1988. I don't have the stamina to explain my (perverse) imagination to a young woman that thinks fetish is a fashion. It is the tunnel through which my imagination travels. Gwen knows. She and I live the lifestyle.

I photograph our friends. We work and 'play' together. Ivy has eaten and been eaten on my kitchen table. RayMan plays me at chess and bites Gwen's flesh ('rough sex') for my camera and his and her pleasure. Brandon is my star male model and collaborator on the initial layout of both Gwen books. He isn't frightened of feeling. The pain and pleasure race across his face when a woman feeds one or more of his obsessions. Ricardo and I go to the same clubs, notably Bondage A Go-Go, on Wednesday nights. He has worked on my web site, www.fetish-usa.com, and been spun around blindfolded in the Marin Headlands.

————— ◆ ◆ ◆ —————

People and some friends conclude there is deep psychological meaning to the fact that other men are pictured making love to my girlfriend, Gwen. I'm certain there is, BUT I can't be in front of the camera and behind the camera simultaneously. That's me, along with my friend RayMan, in the "Martyr for Pleasure" layout but that's NOT how I would have framed me. Yes, I enjoy watching Gwen with men and women but equally important, is shooting the scene in my style.

————— ◆ ◆ ◆ —————

Most people think sex is a taboo subject. It is one thing to have *Fetish Girls* (Taschen 1994) on one's coffee table. The images in that book *imply* sex. The *Transformations of Gwen* books are of sexual imagery. Aberrant sex in many people's opinion. I have a British friend that has an extreme bondage site on the web. He gave away the first Gwen book to a visiting model. I asked him why and he said he couldn't have the book in his house. It was too explicit! An ex-girlfriend, after seeing the first Gwen book, called my current girlfriend a 'slut' and moments later, slammed cushions into my head, screaming "Get out of my apartment" pushing me out the door. 'Gee, I must be doing something right,' I thought.

I like role-playing. I like rubber and leather. I like to spank. I like to obey. I have no respect for 'a private moment' It is the most intimate that I want to photograph and Gwen gives me that.

About Gwen:

She's twenty-six years old. Since a child, she's been obsessed with beautification. She remembers when she was five going with her mom to a hardware store and exclaiming to the woman behind the counter "look, I can put on lipstick in the car without a mirror!" When I first met Gwen (please refer to the introduction of the first Gwen book) she shaved her entire body every second day. Recently, she has let her pubic and underarm hair grow. The difference is she uses conditioner on her pubic hair to make it softer. It is that attention to detail that helps define my photographs. My kind of woman.

Ivy and Gwen going out.

Eric in Williamsburg, VA.

————— ◆ ◆ ◆ —————

An e-mail from a Gwen admirer:

Gwen,

"I was just curious what it was like to do the photo-shoots for your book. Were you scared, nervous, turned-on, excited? I must say, those pictures are the most erotic I have ever seen. How often do you do photo-shoots like that? Sorry for all the ?'s. You just have my curiosity stirred."

————— ◆ ◆ ◆ —————

After the first Gwen book I got (verbally) spanked by my friend and editor Dian Hanson for neglecting to mention some of the photos appeared in *Leg Show* and *Tight* magazine. Ditto for this book. Phew!

————— ◆ ◆ ◆ —————

On a technical note, I videotape my photo sessions and get the sequencing and dialogue for the books from the tapes. I put together this volume on my yellow 48" x 30" formica kitchen table, but I can't complain. James Bidgood (Taschen) made his fabulous and complicated homoerotic photographs in his tiny New York City apartment.

————— ◆ ◆ ◆ —————

Special thanks to Terry Nantier, my publisher with the mischievous smile, Brandon Arnovick, for giving me a hand, and Gwen, the most interesting and kindest person I know.

ERIC KROLL

San Francisco, May 2001

Penis on the Wall

Punishment Shave For Truen Elizabeth

There was a knock on the studio door and Robin, Eric Kroll's office manager, answered. In walked Truen Elizabeth, an eighteen year old lesbian VIRGIN, looking for a job.

"Is Mr. Kroll in ?" the blue-eyed blonde inquired.

Robin handed her a job application form and waited to read it once she filled it out.

"I see you're into chicks," the demure brunette commented.

"C H I X, that's right," Truen corrected, spelling the word.

"Why don't you undress and put these high heels on?"

Truen turned away and removed her white t-shirt. Robin pointed out that if she got the job, she'd have to be comfortable with being nude. Facing Robin, Truen began to remove her white panties. Robin recoiled in horror noticing the applicant's furry bush.

"Excuse me, I must get Mr. Kroll."

Robin left the room and Eric Kroll returned. Inspecting her pussy, he began to pull and pinch her pubic hair.

"If you need this job you must realize this is a professional situation and you can't work here like THAT," he said, pointing in disgust at her hairy beaver. Truen was obviously nervous and in awe of Mr. Kroll.

"What would be a fair punishment for arriving here like you did?" Kroll asked the eighteen year old. "Would it be fair to remove this?" Kroll asked while fingering the short hair on her head. Truen was quiet for a moment then shook her head in agreement.

"Good. Robin had to leave but Gwen will be back in a minute and she will shave you. I could do this," Kroll commented while pulling out strands of her pubic hair, "but I haven't the time."

Kroll disappeared into an adjacent room and then, as if in a play, a stern redhead (looking strangely familiar), dressed in a black shiny PVC catsuit, entered from the opposite side of the room, carrying a container of hot water and a towel. A naked (and hairy) Truen stood frozen, her blue eyes following the siren.

"Where's Robin?"

"Robin had to go home sick. I'm Gwen. Let me see what the problem is. Lay down," Gwen commanded.

"Open your legs."

Standing over her naked, tentative prey, Gwen put on a pair of blue rubber gloves gotten recently from Baja, Mexico. Bending down, she inspected carefully the girl's pussy.

"I don't see what the problem is," Truen began to say.

"You can't work for Eric Kroll looking like this," a not-so-sweet Gwen interrupted. "It is completely unacceptable," Gwen concluded while pulling strands of pubic hair from the girl's body.

"Ouch. I could take care of it. I didn't realize it was such a problem," Truen reasoned.

"You leave THAT to me. I don't see why it is EVEN there. Let me see where your clit is," said Gwen using her fingers. "What a shame. Sit up".

Truen obeyed as Gwen sat down next to her and grabbed her chin in her one hand. With her other hand she ran her fingers through the girls's hair, speaking directly to her at close range, as though she were disciplining a pet:

"In order for you to be here longer than just one paycheck we should get rid of this (the hair on her head) and one other thing. Don't ever ever keep your legs together while working here!"

Gwen, using both hands, separated Truen's naked legs.

"Always apart!"

Relentless, Gwen asked "Do you want to shave your body or not? Do you want the job?"

Not waiting for an answer, Gwen moved Truen's head up and down in mock agreement. Her will had been taken from her. She would obey.

"You do realize this is a `punishment shave'. Good girl. And you will be BALD at the end of the afternoon."

On her own volition, Truen shook her head, confirming eagerly.

"Head up!"

Gwen began to use the professional Oster fast feed clippers across Truen's head with long swipes behind her ears and along her neck. The noise was loud and disturbing. The girl was losing her hair.

19

"Stop fidgeting. Put your hands between my legs," Gwen commanded. The transformation was quick. Clumps of hair stuck to Truen's body. She sat up and waited patiently, obediently, for Gwen to proceed.

"Will you kiss me?" Truen asked.

Gwen, holding her young friend's head in hers, bent low and slowly kissed her full on the lips.

"Looking good. Now lay back," Gwen ordered as she inspected what she had done. Gwen brushed off the hair that had clung to Truen's naked body.

"Now, I think it is time for this to come off," again pulling on Truen's golden pubic hair.

"Don't lift your head to see. Trust me," Gwen commanded as she ran her fingers across Truen's naked body, stopping to pinch the girl's hard nipples.

"Open your legs. Open wider".

After shaving off the pubic hair, Gwen mischievously tried to stuff some of the hair in the girl's naughty mouth. Truen clamped her lips together and wouldn't open her mouth until Gwen pinched the girl's nostrils forcing her to open her mouth for air.

"Sit up. I want you to look at yourself in the mirror... I think you look sweet".

As a reward of sorts, Gwen laced Truen tightly into a beautiful black leather Dark Garden corset.

This time, Gwen wore rubber gloves to apply the shaving cream and proceeded to shave her BALD with a straight razor from Spain. Yet a different sound, the scraping of the blade against the flesh on her skull. She was bald, beautiful and ready to work.

Unfortunately...

Black Sand

PHONE SEX IN SOUTHERN FRANCE

Whenever we travel, before leaving, I put a notice up on my website. We were going to Paris and received an e-mail from Lazarus, a 32 year old Parisian, desiring to 'play' with Gwen.

In our tiny hotel room in the 3rd Arrondissement, as the sun set behind her, Gwen described: "he had me sit up as I felt one of his hands run up the front of me and one running down my back. He was speaking French but I couldn't understand. His hands told me what to do. He lead me to the desk and began to finger me."

Two weeks later, we are in Arles, staying in a large room of a grand "Belle Epoque" hotel facing the forum square. The phone rings and it is Lazarus wanting to speak with Gwen.

I watch her as she smiles broadly, seemingly embarrassed, while sitting back on the bed. She is wearing a tight-fitting button-up-the-front vintage beige sweater and black slacks. A coffee table Man Ray book of photographs lays next to her on the bed.

It begins with the usual casual conversation one would have with an almost stranger that one might FUCK, someone that had already 'played' with you, but hadn't fucked you. In the background one can hear the early evening park sounds.

"Ha. When we get together again and 'play' do you still want to have sex?"

Silence.

"OK. Sure. No, we won't develop them (the previous photos of the two of them) until we get back."

Silence.

"Pierrefond, Fontainebleau."

Gwen adjusts the pillows and leans back against the ornate wooden headboard, listening intently, wired. He suggests visiting the bar Picasso frequented at the nearby Hotel Nord Pinus.

"Yes, we photographed a model today from Marseilles."

From her smile, from little body movements, I know the conversation has shifted to something intimate. I take out my Leica camera with tri-x film and begin to shoot unobtrusively.

"Oh, I wish I had known that a week ago."

Silence.

"It hasn't grown back. The last time I shaved (her pubic hair) was just before I saw you."

Gwen is blushing and looking like she does when she is about to have sex with a stranger: subdued radiance. She

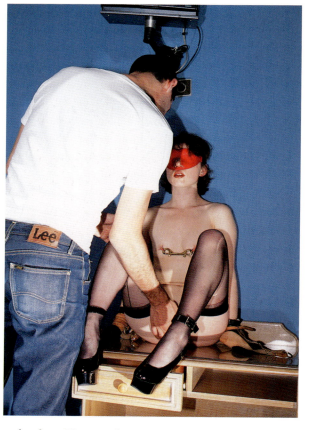

swallows hard then reaches for a sip of water.

"Oh, I think it's a day old." Laughter. "...Since I didn't see you naked, how big is your cock?" Laughter. "20 centimeters."

He suggests she go down to the desk person and ask for a (French) measuring tape.

Silence then laughter.

"So when you fuck me, I want it to be from behind."

Silence.

"Yeah. yeah?" Gwen's eyes dart around the room not focusing. "Well that's fine. I just prefer fingers on the outside, that's all. I'm not sure why. It's always been my preference" (smiling, eyes widening, eyebrows arching). "Umm, yeah." (laughter) "So you want to 'top' me. That is your preference. No, 'bottoming' is really fine with me... A little bit... We'll have to see what happens. And if I were to do that (pee) would you prefer it in your mouth or on your cock?"

Silence.

He is telling her he doesn't want that photographed. And he doesn't want her to pee in his mouth, but he does want to eat her after she pees. She begins to look perplexed.

"OK. No. Only in my head. We just got back. We're going to relax. I just have a sweater on and some panties."

Gwen is smiling and blushing at the same time.

"No, I switch off. Sometimes I wear a girdle... Right now!?!" (raised eyebrows) "Yeah..."

Gwen slides her right hand into the crotch of her pants inside her panties and begins to move her fingers around.

"You want me to masturbate to climax?" (biting her lower lip).

Holding the phone in the left hand, she shifts her weight and pulls down her pants to around her knees.

"No, I don't have one I can insert but I have my little vibrator (pocket rocket) that you used on me before."

Lazarus doesn't seem to understand the distinction and tells her she must tell him just before she inserts her vibrator. He tells her to use her fingers before using the vibrator. Gwen lowers herself down on the bed so that she is lying flat on her back, then kicks off her pants, still wearing wool socks. Her hand is in her panties.

"I just scooted down and I'm playing with my clit."

Gwen is obviously enjoying her new sexual experience. A nearby Church bell rings. The panties are gone and I can see her middle finger circling her clit. In the dimness, I see the light reflected off her long finger nails. He tells her he can't hear her breathing.

"Very lightly".

Gwen is experiencing 'dry mouth' and keeps swallowing.

"How's it going? Going good."

Gwen reaches for her vibrator and turns it on and a loud noise smashes into and off the four walls.

"When I first bought it, it was very quiet." Laughter.

She is rubbing and pressing the head of her vibrator into the fleshy folds of skin around her clit and down the sides of her pussy opening.

"Circular motions mainly on my clit."

Gwen lowers her legs and clamps them together as she moves the vibrator over and around her clit. Smiling, she slowly shifts her legs, tensing one and relaxing the other.

"Hasn't a woman ever explained her orgasm to you before? Are you masturbating now?" He tells her he is. "Alone?" Yes. "Where?" In his bathroom, he tells her. "I don't want you to come yet."

Gwen's legs are spread wide apart as she continues to play with her pussy by raising it to meet the downward motion of her pocket rocket. She is smiling into the phone. He suggests she come to Paris for three days, ALONE.

"It would be fun but I don't know about this visit."

She closes her eyes for an instant and points her toes forwards and tenses. There is a small groan into the phone as her pussy rises off the bed for an instant then settles back down.

"I came. I came quietly."

Gwen's right hand, still holding the vibrator, falls to her side. She then opens her hand and the vibrator rolls onto the bed. It has done its job. She is listening into the phone. Her left leg is bent at the knee and her right leg is flat on the bed pointing at the far right window. Her pussy is spread, there's moisture at the opening and she is comfortable with her nudity and satisfied. Lazurus groans into the phone and has trouble finishing his sentences.

"They (women's orgasms) are longer," she remarks to him.

They chat for a minute and she hangs up and looks at me with her legs spread and her lips forming a broad smile.

A Martyr For Pleasure

When I was growing up in the 1960's in Westchester county, an hour north of New York City, there was a suburban myth stating that, if a girl wore green on Thursday, she was a lesbian.

At the turn of the millennium, Gwen and I would party on Thursdays. My kids were at their mom's and we would have friends stay over so we could stay up late, drink a lot of booze and/or take 'dirty' pictures.

One Thursday in August, 2000, I realized I needed to do something perverse. My life seemed too ordinary. I found my chess friend RayMan at the Red Room bar and told him of my plans.

"Oh, you want to do something 'arty'."

No I want to do something edgy, dirty, perverted with Gwen. Punishment? Jealousy? Love? Who knows. I warned her it might get sexual. I had an image in my mind of a woman (Gwen) bound upside down, wrapped in saran wrap, fifteen feet off the floor, being eaten while giving a blowjob. Just a thought. I didn't tell a soul.

Back at the studio, I dismantled and removed all objects near the two heavy duty eye hooks stuck in the old ceiling. Gwen showered and shaved her pussy.

Later, upstairs, she asked too many questions. How would we get her up there? Would it hold her? Selfish questions. RayMan and I laughed and kept busy. Naked and apprehensive, Gwen laced up her long black leather boots. It was my job to wrap her and the only thing left exposed was her bald pussy. She was beautiful and feisty as she stuck her ass out towards RayMan who stood on a tall ladder and made video or pouted in my direction as I took photographs. Her arms were pinned to her side. Her face was flushed and she was turned on.

Finally, she was laid backwards across RayMan's shoulders as he began to climb the ladder while I held her shoulders and took some of her weight. When he was high enough, he asked that I lift her, taking most of her 106 pounds, as he struggled to clamp one ankle cuff then the other to the eye hooks. I could feel her slipping through my grip towards the FLOOR. She was mummified and not helping. She was dead weight.

"I don't like this," she exclaimed as I pushed her shoulders up with all my strength.

"I can't hold her," panic in my voice. Snap, snap, she was in.

"Oh my God, you're never going to get me down". RayMan stood above her on the ladder looking down between her legs and laughing. I was laughing also. Nervously. I was trying to take photos, The Great Photo. I was acutely aware of the circumstances and I was making mistakes.

RayMan tickled her sides but she wasn't responding.

"I'm too fucking freaked to be tickled."

"What's going ON? My ankles…"

"OH MY GOD" (said very slowly with a pause between each word. Eye contact with fear). She was facing me. She was facing the camera.

"I'd feel much more comfortable going the other way. How the fuck are you going to get me DOWN?" Gwen sounded pissed. I suggested RayMan spit into Gwen's hole while standing on the ladder above her. It would make a good photo.

"I can't do this for very long," Gwen pleaded.

Naturally, I ran out of film and had to waste precious time chang-
ing films. She looked beautiful as color rushed to her face against
the blue, green and red shiny colors of the wrap. It never occurred
to me she might fall. If she did, she would die. I was thinking 'com-
position' and thinking about her perfectly shaved pussy.

Too soon, I had to lift her, as RayMan unclasped her ankles.
Then I gently rolled her down the ladder
to the floor.

She lay in a heap as we stood staring
down at her colorful mummified form.
We decided to attach her to a nearby
decrepit blue chair and suspend her
between the floor and the ceiling. I ball-
gagged and blind-folded her as RayMan
tied heavy rope around her body and
around the chair. He passed the two ends
through the eye hooks in the ceiling, then
I lifted the Gwenchair past the fulcrum
point as RayMan held the rope. It was an
homage to Bunuel and Dali's "Un Chien
Andalou" (1929). Instead of a donkey, a
piano and two priests it was a wrapped
'Gwen with chair'. She tilted beautifully
and I had to relift her past the fulcrum.
Photos then murmurs then more photos
then slowly she was lowered back to the
ground.

I bent low to her ear and asked her if she had had enough. She thought for a moment then silently shook her head, drooling out of the left side of her mouth.

Part of the heavy rope was wrapped around her neck and the chair tilted back so that she couldn't move her neck without choking. I could hear her moaning as she tried to push the rubber ball gag out of her mouth using her tongue.

"What's the matter, do you want to breathe?" RayMan asked laughing.

Wearing a silver Effigy talon on each of the fingers of his right hand, RayMan stepped over and pushed the gag back into her mouth, using the sharp end of one of the talons.

The next day, Gwen explained (forever the submissive) that when her jaw began to ache from the ball gag, she thought about the expected blowjob she thought she'd eventually have to give and worried she'd be unable to perform because of the soreness. That's when she tried to get the rubber ball out of her mouth.

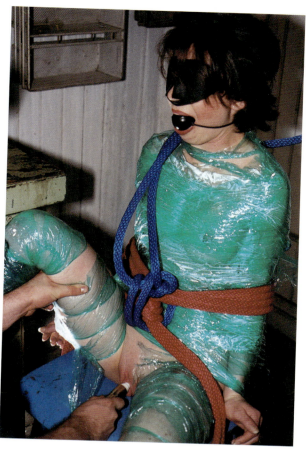

RayMan ran his metal spikes along her cheek, then the flesh of her neck. She continued to murmur. She kept trying to close her legs. Her pussy was open and as she tried to move, I jammed my leg against her leg so that her pussy remained vulnerable, open, and pink from the rubbing I was doing. We took turns playing with her. RayMan squeezed her nostrils cutting off her remaining air supply while holding her head still with his other hand. She refused to react and he stopped as I reminded him that she was asthmatic. I poured cold water down her front, inside her saran wrap. We tickled her from all sides watching as her body reacted in one jerky movement. When I went downstairs to retrieve more supplies, RayMan walked over to her wrapped immobile body and sat his 200 pounds on her spread legs and danced the talons across her mummified body.

Later, the round end of her vibrator found the fleshy part of her vagina. The spokes of a small medical pinwheel moved over her flesh to the very inside of her thighs. She began to moan louder, moving her head from side to side until her pussy jerked forward.

Hours later we quit, assuming Gwen wanted to stop. Later, downstairs, after RayMan had retired to his room, she told me she'd hoped we would do MORE, be more sexual but, forever the 'sub', she thought it was expected of her to want to stop! I suggested next time she say something like "I came. Don't you two want to come?"

Gwen said it was extremely enjoyable to be played with by two people while blindfolded and helpless. Not knowing who was doing what to her. Who was snapping the photos, who was poking her neck with a metal talon as her head snapped back to avoid the sharp points. Who was stroking the insides of her pink thighs. Being in the chair made the bondage comfortable, avoiding the usual ache that came from standing in extreme heels which usually led to some part of her foot falling asleep. She said hanging upside down with her arms pinned to her sides made her feel like a fly trapped in a spider's web.

Two nights later I noticed her getting into bed with her vibrator. "Eat me!" Another positive indicator she had had a good time two nights before.

43

Souvenir

Eventually Gwen and Berent broke up but she kept a...

...souvenir

Nimese

Gwen and I go to Power Exchange, a local sex club, to 'play' and to see whom there is to see. One night, from across the basement, I viewed a petite, very young blonde speaking with a 'regular'. What was this beauty doing alone in such a sex club? Was she my (and Gwen's) cosmic gift for the evening?

Pretty Nimese told me her boyfriend was next door and would return soon. He returned. We spoke. She dropped her pants and Gwen spanked her tan-marked ass. Nice, but not nearly enough. We agreed to meet again the next day in my studio.

Gwen and I rose early and went to Baker Beach where I stenciled into her freckled back SLAVE TOY. Later, in the studio, she wore a rubber chin dildo and nothing else.

Nimese arrived in her cute riding attire and allowed Gwen to undress her. Her boyfriend and I stood transfixed as the two beauties played together. Gwen kept nudging her face penis into Nimese's eager (she kept thrusting her pelvis forward) pussy. I suggested her boyfriend and I leave the room, the building, the area. I left the video camera running. The girls needed to be alone, but recorded. Forty five minutes later we came back and they were on their knees in full embrace.

"You're blushing," I pointed out.

"I'm not surprised," Gwen countered, smiling.

I asked what happened and they exchanged excited glances.

"Buy the video," Gwen suggested (laughter). A year later I sat alone (with a hard-on) and watched a very very hot video: On her knees, wearing a pink chin dildo strapped to her platinum blonde head with "slave toy" sunburned into her back, a naked Gwen unbuttoned the side buttons of bare-chested Nimese's corduroy jodhpurs. I enjoyed watching her small white breasts framed by a golden tan. Nimese lubed the phallus attached to Gwen's face, smiling down on her lover. As Gwen rose off her hunches, the face penis poked between Nimese's vagina lips. Gwen's movements were like a strange gymnast's exercise. Machine-like, she came up then down then forward again sometimes holding on to the

wall with her right hand as her left hand felt Nimese's thigh. To enter her from below she had to arch her back exposing her pussy and asshole to the video camera. Fucking her partner from her kneeled position caused her to make piston movements as Nimese opened her thighs and curled her pelvis, better to be entered. They exchanged glances and giggles. At one point Nimese grabbed the shaft and guided it deeper into her pussy. Using the wall for leverage, Nimese bounced her ass against the hard surface and accepted Gwen's chin thrusts. I could hear traffic noises coming from Van Ness Boulevard. A horn honked as Gwen stopped and reached out of frame for a 'pocket rocket' vibrator. Holding it with her left hand, she placed it on Nimese's clit as she bent low and brought her chin dildo back into Nimese's pussy.

Their movements were syncopated as Nimese began to moan quietly, then not so quietly. Gwen's movements were like a giant industrial accordion bellows of a fan or a character out of a Chaplin silent film about the future as she rose and fell, thrusting. Nimese reached down and held Gwen's head so the penis that extended from her face wouldn't retreat SO far from her pussy. Her other hand spread along the wall. It

appeared she was about to collapse. Her eyes closed. Her moans became louder.

"Ah. Oh, God," head back, upper chest spasms then pelvic spasms then stillness.

"I loved that," Nimese said with a satisfied grin.

Both remained on their knees close together. Nimese's riding pants were still bunched up below her knees, her velvet brown riding helmet still on her head.

"Do you want me to play with you?" Nimese graciously inquired.

"You can do whatever you want to me. I'm your sex toy," Gwen replied removing her chin dildo.

"You can eat me if you want."

Glances and smiles and eyes downcast.

"You can beat me if you'd like," Gwen offered, placing her hands on the nearby

wall and presenting her ass to Nimese. Nimese picked up a Whips of Passion red and black leather flogger and tentatively began to flog her. Asking questions, she experimented on Gwen's back and ass. After a time she found Gwen's private 'pocket rocket' vibrator and, bending low, slipped it between Gwen's ass cheeks to find her pussy. Kisses and caresses, then Nimese gently turning her so that they faced each other. Holding her at the waist with one gloved hand, Nimese kept Gwen's body still as she pressed the vibrator to her pussy. Gwen began to respond. She opened her thighs and leaned one hand against the wall as Nimese ran her kid glove over Gwen's tiny tits. I saw her bend low so that she could see where she was placing the head of the vibra-

tor. Her tan hip and pale buttocks leaned into Gwen's chest. It was a way of seeing where the vibrator touched her lover's pussy. It was accidental, yet very erotic to watch. Gwen froze and laid her hand on Nimese's shoulder as her head tilted slightly. One climax. Then moans in sync with Nimese's movement of the vibrator. Then louder moans as Gwen leaned forward, resting her head in the arch of her own elbow, pulling Nimese to her. Another short climax. A suspended moment then kisses, embracing and petting. Nimese sucked on Gwen's tit, then laughter. Then embracing then: "Hi" it was my voice. I could see myself coming through the door. "You're blushing."

The rest is obvious. Her boyfriend was turned on. He got his blow job. Nimese got eaten to climax AGAIN.

I got my pleasure.

Gwen got hers.

Bad Boy Needs Punishment

Good looking athletic SWM, 25, into role playing, CBT, NT, spankings and whippings.

Gwen decided to test her strength on the body and mind of a muscle bound man. She found him in a personals ad. They met at a local bar and she brought Rick, as we'll call him, back to the studio.

She stood with her hands on her hips as she told him to undress. "Place your clothes in the hallway." He complied and returned naked except for his blue and white boxer shorts. "Underwear, too."

He turned away as he stepped out of his underpants.

"You're not shy are you?" she asked with a smirk.

Gwen signaled for him to approach her then fingered his gold necklace.

"What is this around your neck?" she asked as her hands ran freely across his compliant hard body.

"Turn around."

She smiled as she felt with both hands his white buttocks then slapped each cheek sharply. She told him to turn back around and face her. He was rock hard. His cock bobbed as she pinched his nipples. He looked down as he watched her fingers move across his chest, passive and obedient. He was transfixed.

"You've never done foot worship?"

"No," as he fleetingly touched his penis.

Instantly, she slapped his dick.

"Don't touch your cock. Get on your knees." Her voice was stern.

Gwen relaxed into the seat of an old metal dentist chair and presented her black leather stiletto high heel. He eagerly licked and kissed her exposed calf area.

"Do you want to take off my heels? You don't need to unbuckle the strap."

SLAP! Gwen leaned forward and smacked his slightly raised ass.

"Ooouch," Rick complained.

"Did I say you could touch yourself?"

"No, mistress," the muscular kneeling man responded. "May I touch my penis, Mistress Gwen?"

"No you may NOT. Kiss my feet."

Quickly he returned to her bare ankles, licking, slurping and kissing her flesh. As she raised and lowered her feet at will, his tongue followed. She controlled him. The nails of her left hand traced flesh designs on his back.

"Kiss my thighs" as she guided his head up to the leg of her skin-tight Syren black rubber capri pants. She was slowly running her hand through his hair the way she would reward an obedient pet. Good dog.

"Not my pussy, my thighs," she corrected Rick as he tried to dive between her thighs. His slurping noises were getting louder.

'Enthusiastic,' she thought as she watched him respond to the latex shield over her body. Gwen stood and leaned against the studio white wall presenting him with her rubber-covered ass. He silently placed his nose and mouth at the bottom of her ass and then licked. He again began to touch his hard penis but drew his hand away quickly.

"Mistress may I play with my penis?"

"No."

"May I?"

"Don't beg me," Gwen reminded him sternly.

He resembled a sleek dog humping the leg of his master as he buried his tongue deeper and deeper into the crack of her latex ass. His breathing became heavier.

"Put my shoe back on."

She moved behind him and began to inspect his kneeling naked body.

"Stand up. WHAT ARE YOU D O I N G!"

He had grabbed his penis. Swiftly and violently, she grabbed his hair and pulled his head back until he moaned in pain. She spanked him hard over and over with her bare hand.

"Did I hear you say 'ouch'?"

"Thank you, mistress."

His eyes followed his mistress as she went to a nearby pile of toys. She returned and clamped to his nipples a set of clamps joined by a chain. He stood erect and at attention as she outlined his body with both her hands. Next, she knelt and placed a complex leather cock-ring around his engorged balls.

"Why are you doing that, mistress?" Rick asked while motionless.

"Because I want to," she replied, emotionless, as his cock got harder.

Gwen lead him over to a door frame and was about to flog his back when she noticed him AGAIN touching his cock.

"Why are you playing with your cock if I told you not to?"

"Because I want to play with it SO bad."

"Well, you're not going to right now."

She laid out her floggers. Beginning with a black rubber flogger she concentrated her blows on his ass. Whap. Whap. Over and over. She stopped and approached him, reaching around to his front and gently pushed his belly out, further exposing his ass to her flogger. There was no hurry in her movements. He was there by her clock. She would do with him as she pleased. She returned to beating him rhythmically then stopped to feel his red ass.

"So warm," she commented out loud to herself.

She ran a black fur mitten lightly across his raised skin. Next she grabbed a yellow deerskin flogger and began to beat his upper back.

"Where is your pain threshold?" "I don't know. Can we find out, Mistress?"

She flogged rhythmically then suddenly harder. Every so often she would pause to feel the results. One could see she was enjoying his muscularity, his fitness, his passivity.

"Do you ever shave your legs or only your chest and balls?"

"Sometimes I trim," Rick replied above the din of the whipping.

"Come on. Stick it back out. How does that feel?"

"Good," Rick confirmed stopping to adjust his body position. He remained compliant.

"Spread your legs," Gwen ordered as she laced the flogger between his upper thighs flicking his balls then going across his back with a figure 8 motion, letting her wrist snap at the exact moment, allowing the strands to fly forward and hit their mark. Switching to a braided whip she began to hit harder. His ass cheeks tightened involuntarily.

Using a hard rubber horse-brush with rubber protrusions, she rubbed his back and buttocks- her fingernails following where the brush had been. Gwen was constantly checking her handy-

work, grooming and controlling. Cuddling him with one hand, she would inflict pain with the other. One hand soothing, the other tightening the nipple clamps. Pain/pleasure. Finding his threshold but making him feel secure in her grip. Like a small herd of buffalo I saw out west that were 'held in' by a wire fence they could have easily broken through, Rick was obedient because that was what he wanted to FEEL. He had voluntarily given over his power to Gwen. At any moment, he could have thrown her aside like breaking a small branch of a tree. Instead, he stood awaiting her next command.

"Come here. Down on your knees."

His cock was enormous as he turned and followed her instructions.

"Stay there until I return."

Gwen walked into an adjoining room and returned with a fist-full of wood clothespins. She walked to the front of his prone body and trapped his head between her rubber thighs at the base of his neck. Leaning forward, she spanked his ass.

"Next time you should think of shaving before coming to see someone."

"Yes, mistress."

He had displeased her.

More physical punishment.

"Does that bother you?"

"Yes, it hurts."

Dispassionate, removed, she again grabbed the hair on his head and felt between his legs. She made him stand up.

"Hands behind your back."

She knelt in front of him and placed one and then another clothespin on his cock. Slowly, she walked back to the dentist chair and sat down. She indicated she wanted him to crawl to her. She pointed and he came.

"Eat me."

His excitement grew as all his senses were surround-

ed by RUBBER. She began to whip his ass and upper back with the black rubber whip. His breathing became heavier. His nostrils filled with the odor of latex, the taste of latex. The more he tasted, the more eager he became. She had found his kink and it was RUBBER.

"So anxious," she noted, looking down on her subject as she pulled his head from her crotch.

Moments later, she allowed his face to return to her box as she cuddled his head and marveled at his enthusiastic tongue movements.

She decided to `play' him all night. She would let him touch himself but only after he'd put on a LATEX condom. And only after he had tasted (worshipped) her new black with red trim rubber panties.

Camille

She came from the East and played in the West.

She got covered with honey in the bathroom...

...and in the bedroom.